Cup

Soap

Balloon

Spoon

Plane

Sailboat

Drum

Camera

Pencil

Bottle

Chicken Leg

Speed Boat

Case	Clamp
Bulb	Sponge

Helicopter

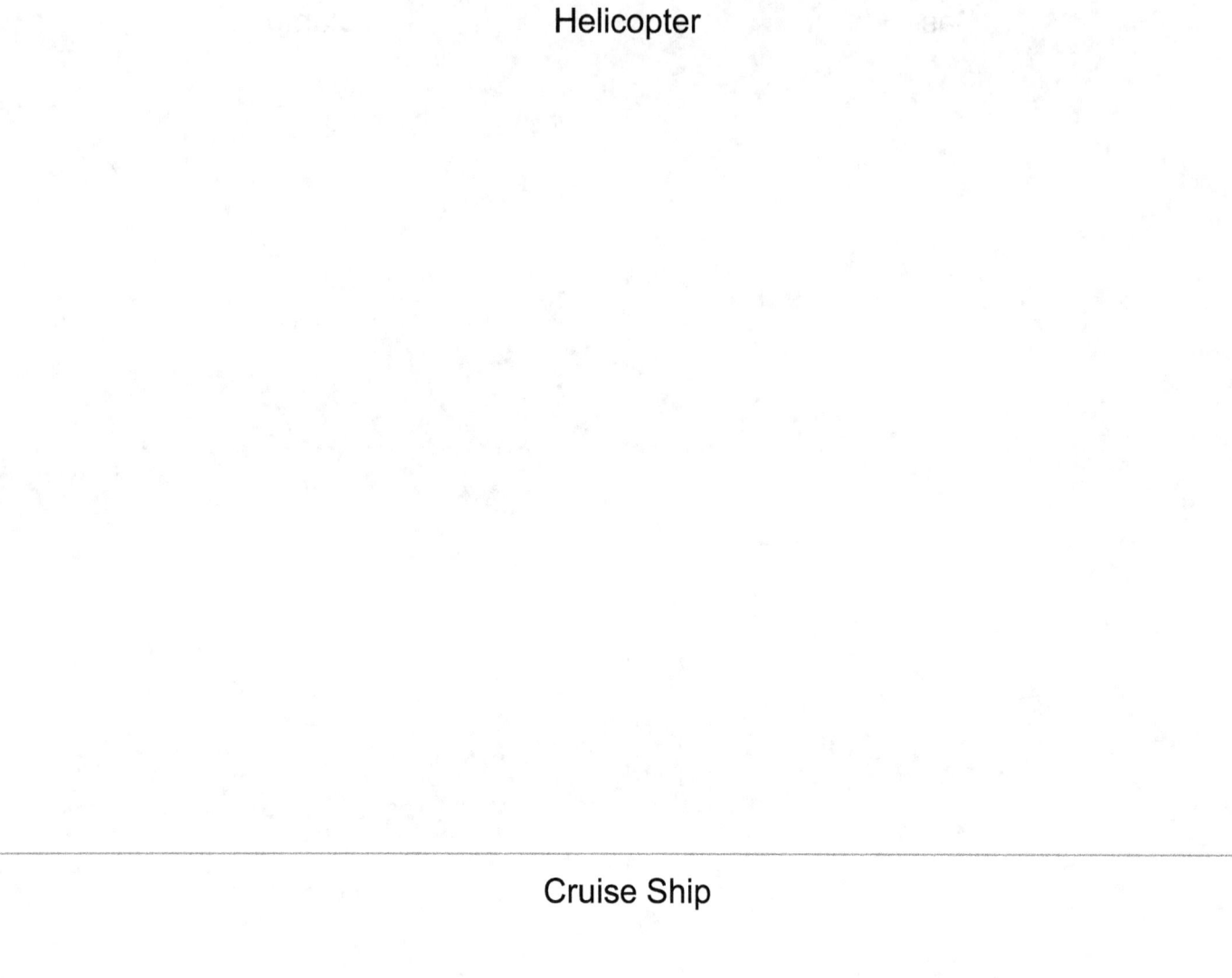

Cruise Ship

Fork

Campfire

Fork Lift

Street Light

Wagon

Tent

Wizard's hat

Baseball

Stapler

Candle

Key

Bridge

Cart	Sunglasses
Jewel	Can

Elephant

Crown

Cake	Cookie
Clock	Phonie

Castle

Carriage

Clover

Heart

Pineapple

Cactus

Bird

Teapot

Flower	Bed
Bowl	Brush

Owl

Banana

Bee

Tree

Teacup

Cauldron

Fish

Pickup Truck

Dog	Desk
Lamp	Apple

Couch

Train

Crib

Cow

Eye

Book

Firetruck

Sandwich

Calculator	Tower
Feather	Orange

Fence

Dock

Top Hat

Bell

Ice

Hydrant

Rabbit

Tub

Scissors

Chef Hat

Skateboard

Log Cabin

Cat

Baby chicken

Lighthouse

Egg

House

Bus

Duck

Christmas Tree

Star

Scarecrow

Guitar

Spaceship

Wizard's Chair	Squirrel
Astronaunt	Hotel

Car

Magical Lamp

Ladybug

Scientist

Library Shelf

Police Hat

Toothbrush

Cowboy Hat

USB drive

Stop Sign

Mushroom

Dog House

Semi Truck

Horse

Semi Truck

Baseball Glove

Nose

Monkey

Doctor

Tiger

Butterfly

Sock	Hand
Bear	Giraffe

Cupcake

Earth

UFO

Tree Fort

Trophy

Slug

Monster

Shark

Shoe

Coin

Umbrella

Turkey

Hotdog

Snake

Tuba	Ice Cream
Ear	Moon

Witch

Flag

Snowman

Alien

Playing Card

Ferris Wheel

Fish Tank

Mountains

Turtle

Rose

TV

Pez Dispenser

Logs

Binoculars

Garbage Can	Donut
Street	Dartboard

Cheese

Spooky Cave

Robot

Cowboy

Pyramid

Surfer

Tornado

Sweater

Spider

Pretzel

Crystal

Rock

www.ingramcontent.com/pod-product-compliance
Lightning Source LLC
Chambersburg PA
CBHW081657220526
45466CB00009B/2789